T0150629

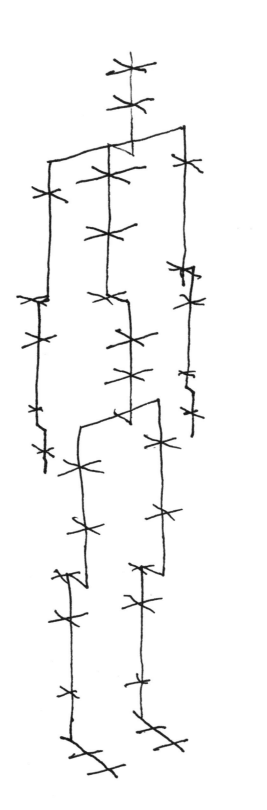

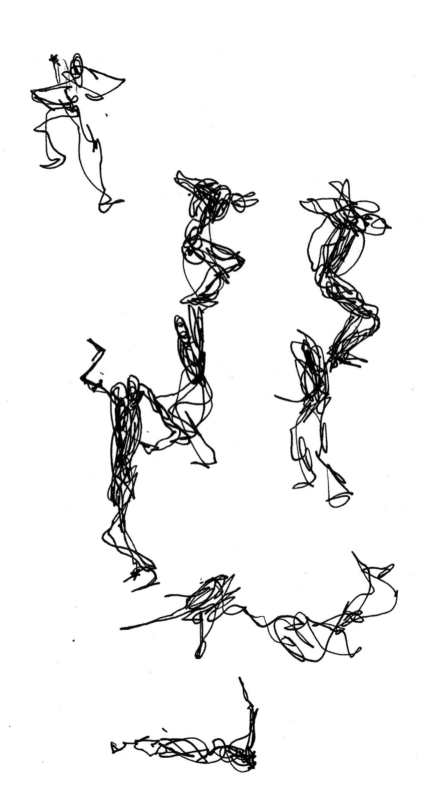

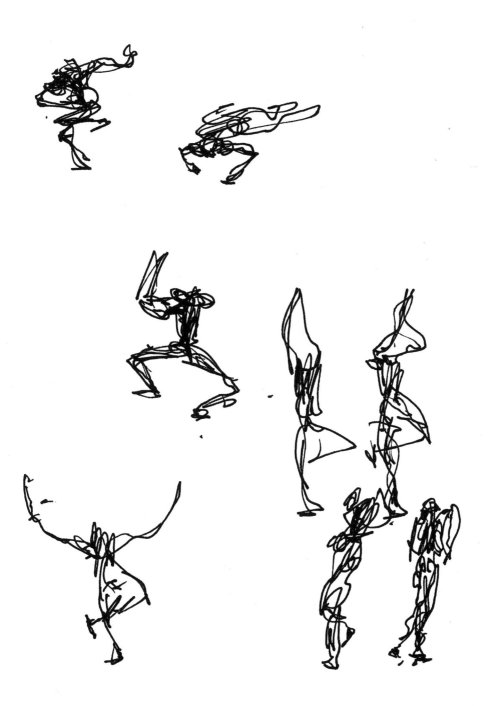

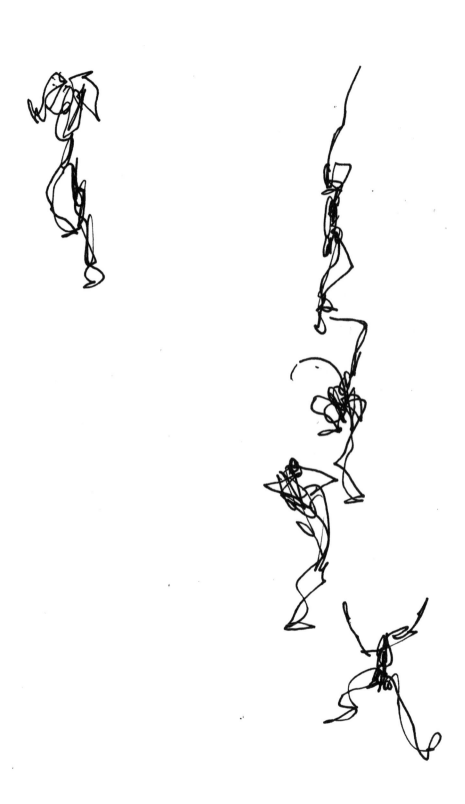

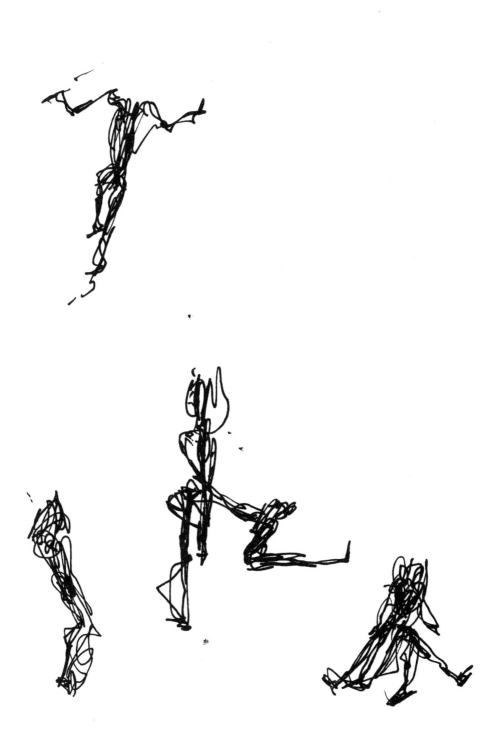

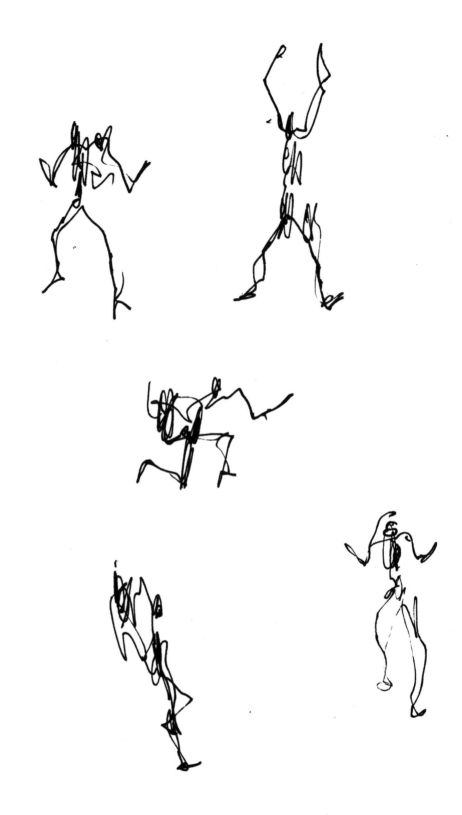

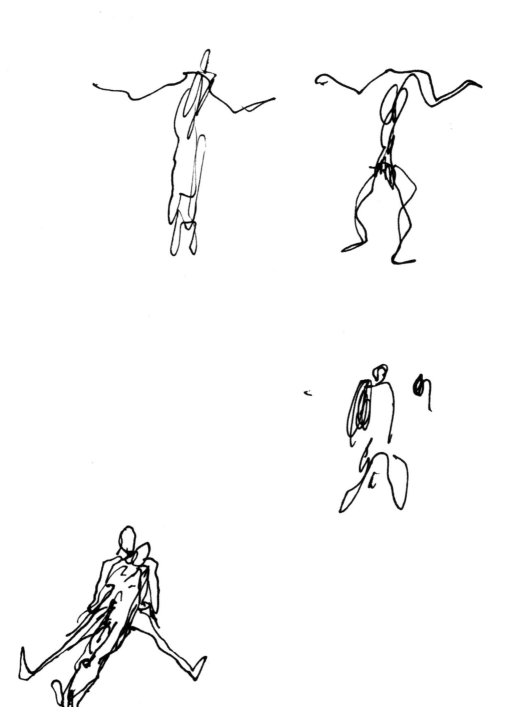

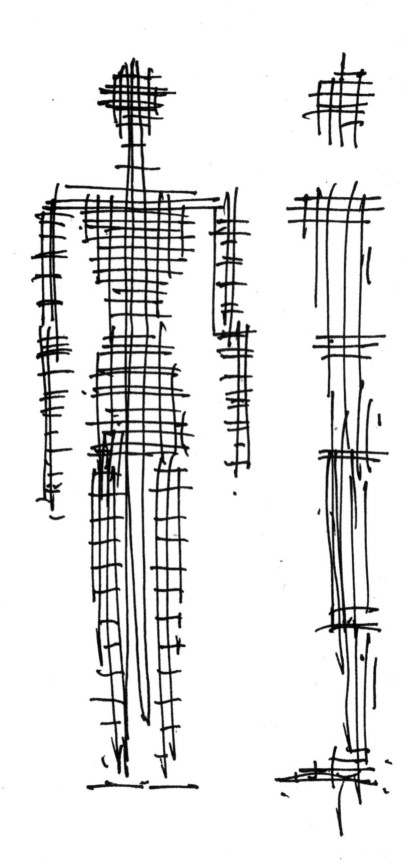

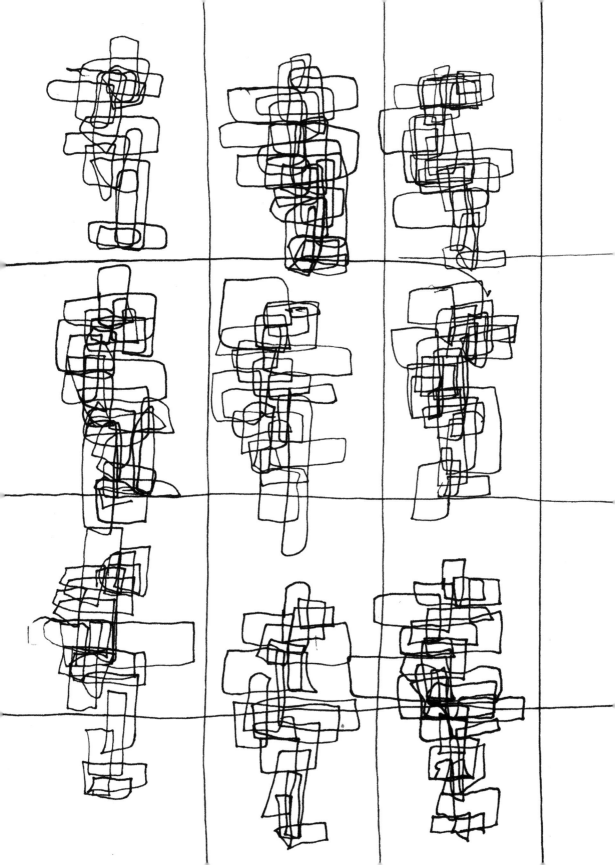

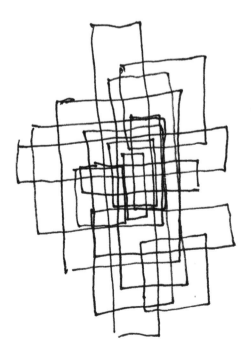

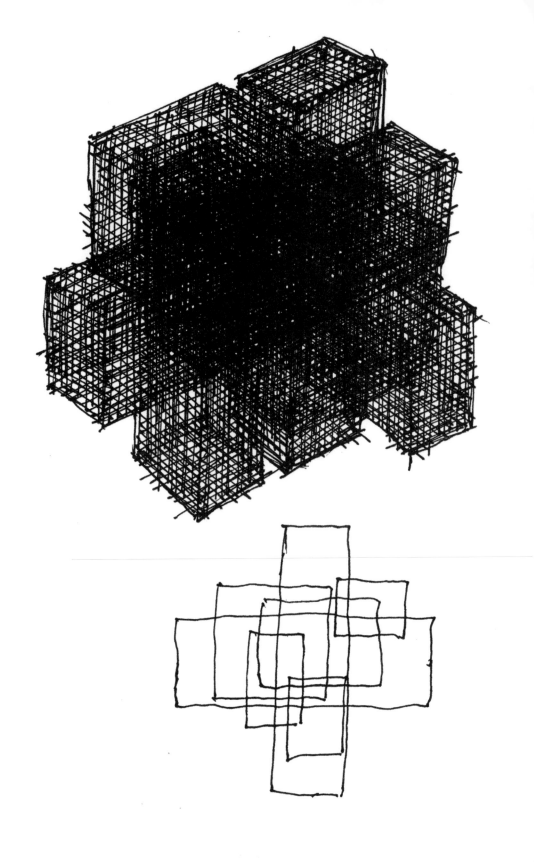

maybe 6 mm?

possibly
greater density
in area of
maximum
tension

Workbooks, 2016–18
Pages 1–25

Preface

Andrew Nairne

'... making a space for art isn't about sensibility, it's about something else, it can extend the possibilities of art: what art can be. It's not about making beautiful spaces, but making a test site for human art and life. How can art help in the making of a collective future?'

Antony Gormley, in conversation with Jamie Fobert and Jennifer Powell, 2018

Antony Gormley is profoundly ambitious for his art and art's place in the world. He has spoken of how art can make us rethink who we are and where we are going. As part of the University of Cambridge, Kettle's Yard's role, through the visual arts, is to enable exactly this kind of discourse. Our aim is to be a place of research and constant enquiry, not to accept the given but to challenge the status quo. A major new exhibition at Kettle's Yard, SUBJECT, offers a series of choreographed physical and metaphysical encounters, exploring our relationship to space and our sense of self. Essential to Gormley's intention is that we actively participate, so we become co-producers of meaning and value, through seeing, thinking and feeling.

As the texts within this publication suggest, perhaps SUBJECT is not so much a traditional exhibition, as a live experiment. How can art make us more alert and conscious of what it means to live now and of our potential as agents of change, shaping the future?

The making of SUBJECT and of this book would not have been possible without the close collaboration, commitment and support of many individuals and organisations. Our sincere thanks to all at Antony Gormley Studio, particularly Bryony McLennan, Laura Peterle, Ocean Mims, Jamie Bowler, Ondine Gillies, Anna McLeod, Rosalind Horne, Alice O'Reilly, Philip Boot and Tamara Doncon; to The Bon Ton (Amy Preston & Amélie Bonhomme) for their superb design of this publication; to Benjamin Westoby for his photography; to Caroline Collier for her insightful new

essay and Jamie Fobert for his participation in the conversation published here; to Daniela Gareh and White Cube for their vital assistance and to all those who have so generously helped by joining the Antony Gormley at Kettle's Yard Supporters Circle. At Kettle's Yard, I am especially grateful to Jennifer Powell who has led the curatorial and organizational teams; Guy Haywood for overseeing the installation of the exhibition; and to Susie Biller, Cherie Evans, Amy Tobin, Steve Penny, and Morag Walsh Barnes for their respective contributions.

Our greatest thanks is to Antony Gormley, for accepting our invitation and so brilliantly conceiving of SUBJECT in relation to our new spaces, as a physical, material and philosophical proposition for our times.

SUBJECT

Jennifer Powell

The opening pages of this book were selected by Antony Gormley from one of his many small drawing notebooks that he carries with him. Drawing and notation are central to Gormley's working process, helping him to explore ideas and feelings. Some of these sketches are more directly related to works in this exhibition, some to other projects, and all reflect an ongoing investigation into the conditions of the human body. Rather than pursuing observation or the translation of appearance, Gormley's ongoing enquiries push a deeper questioning of how sculpture can communicate an attitude of the body – what it feels like to inhabit one. Early in his career, in 1983, Gormley stated that: 'I realised that work dealing only with objects is incapable of carrying the kind of feeling that I want. I am now trying to deal with what it feels like to be in a body. To make an image that in some way comes close to my state of mind. My body is my closest experience of matter and I use it both for convenience and for precision. I can manipulate it both from within and without. I want to recapture for sculpture an area of human experience which has been hidden for a while.'[1]

'Let's test this new gallery', was Gormley's call to action for this exhibition. In fact, Gormley has been testing galleries, testing architecture, testing materials and testing the limits of the internal and external body since he was a student. His work aims to activate us, to act as a hinge for a physical or emotional response, rather than existing only as 'form' to be passively observed or admired.

The artist's research for this exhibition has always centred around the relationships between the work and the architecture of the new spaces at Kettle's Yard designed by Jamie Fobert Architects and opened

[1] Antony Gormley in 'Antony Gormley Talking to Paul Kopeček', *Aspects*, no. 25, Winter 1983/84, p.4.

29

in February this year. The selection of the five works that now occupy and disrupt the spaces, took many turns. However, these conversations always returned to Gormley's deep engagement with the building, perhaps considered as the architectural skin for this installation.

This exhibition, illustrated on the pages that follow, interrogates the body in space and the body as space. The installation is hinged on *Co-ordinate IV* (2018, pp. 33–37, 42–53), which comprises two thin and taught horizontal steel rods that pierce through the two galleries, shooting out through their doors into the public spaces between them. Here they also cross. Another vertical steel rod crosses the horizontal axis in the Sackler Gallery. These three steel co-ordinates, which the artist has described as being like the strings on a musical instrument, push against the walled structures of the galleries with 3 to 4 tonnes of tension. They measure, disrupt, disorientate and activate both space and the viewer. In Gallery 2, *Edge III* (2012, pp. 48–53) is positioned just off the floor and at 90 degrees to the wall. The figure is a 630-kilo body cast of solid iron, yet in the gallery it appears weightless, floating in the changing light that is cast on the space through the roof lights (intentionally borrowed by Jamie Fobert from Leslie Martin's 1970 extension to the Kettle's Yard House). Hanging from the ceiling of the Clore Learning Space, *Slip I* (2007, p. 59) dives downwards, inviting our gaze at different viewing levels. A body caged within its external skin, it is made from steel rods like *Co-ordinate*, which here map the body with lines of latitude and longitude similar to those on a geographer's globe. Upstairs in the Edlis Neeson Research Space, *Infinite Cube II* (2018, pp. 55–57) is on view for the first time in the UK. The cube radiates co-ordinates of a kind, replacing lines of steel with beams of pulsating light that seem to be both contained within, but also burst forth from, their glass cube. Like the steel rods downstairs that feel as though they might escape through and beyond the walls, these pathways offer infinite possibilities which might transport us beyond the physical, to consider the limitless space of the mind.

SUBJECT is Gormley's provocative title for his exhibition at Kettle's Yard. The title is borrowed from another new work that the exhibition contains: *Subject* (2018, pp. 36–41) is a tightly packed body zone, woven with a grid of steel bars that map the internal space of the body. The figure stands, with head bowed, in a position of self-reflection. Who, or what then, is the 'subject' in this exhibition? The sculptures – their materials and forms; the architecture – its light, space and volume? Most vital to these dialogues is you, the viewer. Your own body, its

relationship to the works, to the space and to others who might occupy it, and the resulting experiences or feelings that these encounters might activate. SUBJECT, as an exhibition, communicates a plurality of these exchanges, but the body remains its constant. The artist expresses this well:

'Both in the demands that it makes of the viewer and in the way that this exhibition uses the spaces of the gallery, the show asks where the subject of art can be found. I am proposing that it is rooted most powerfully in the imaginative engagement and ultimately the memory of the viewer. The wager of this show is that 'subject' is transferred from object to experience.'

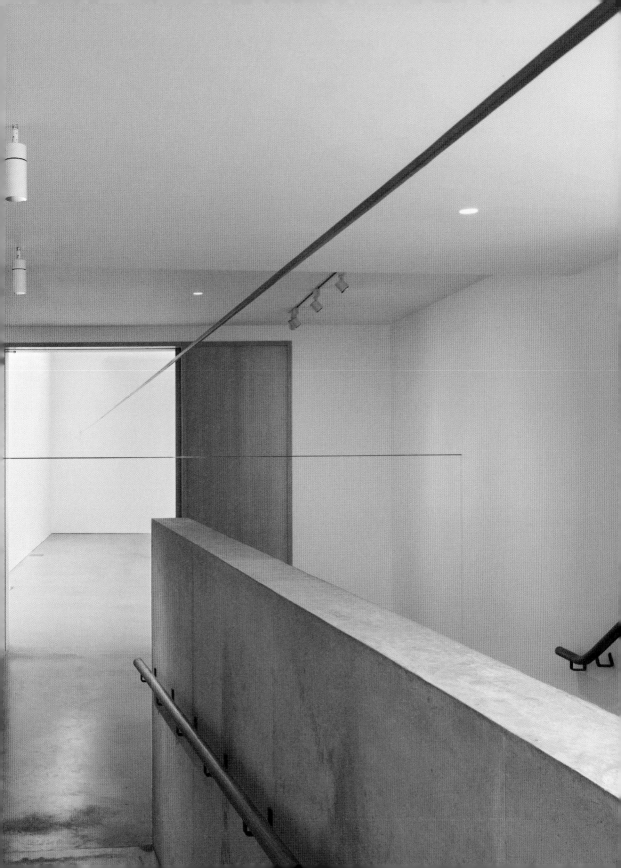

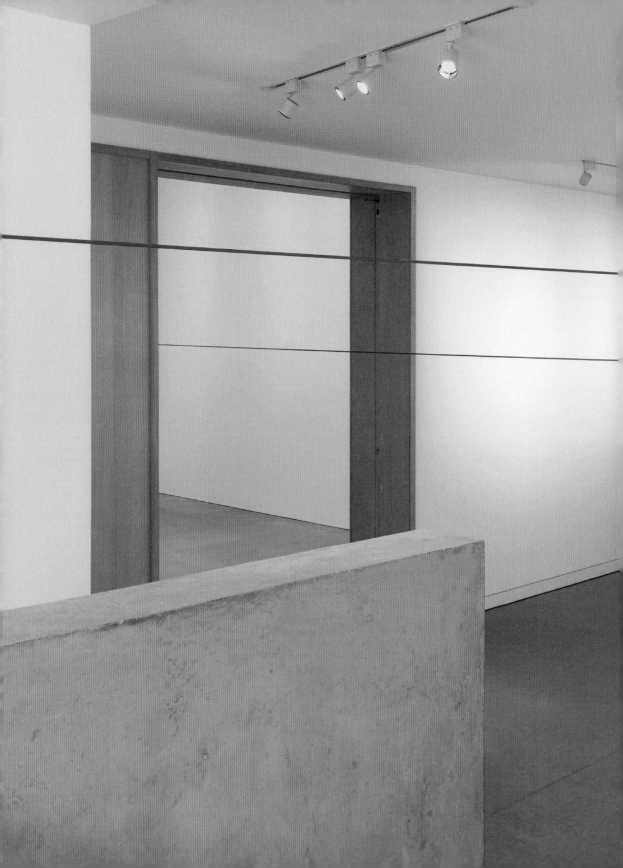

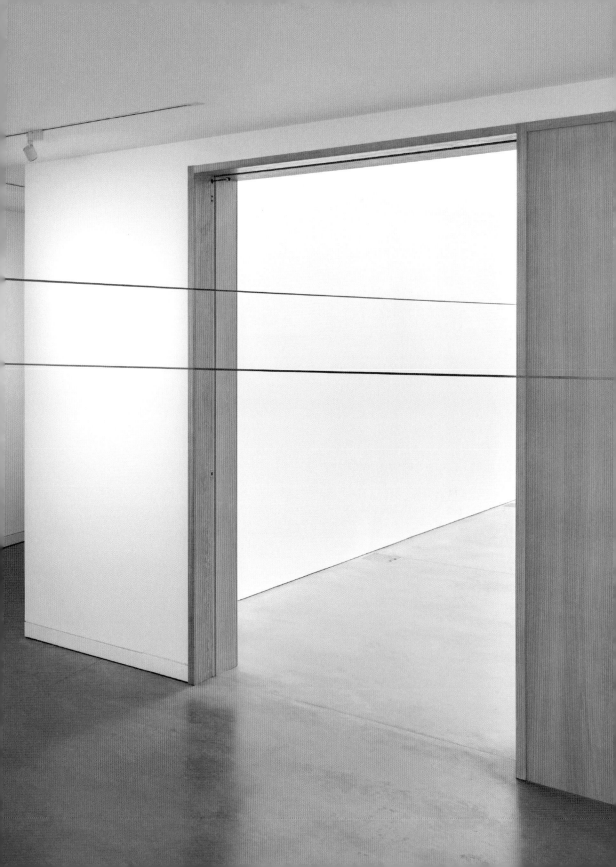

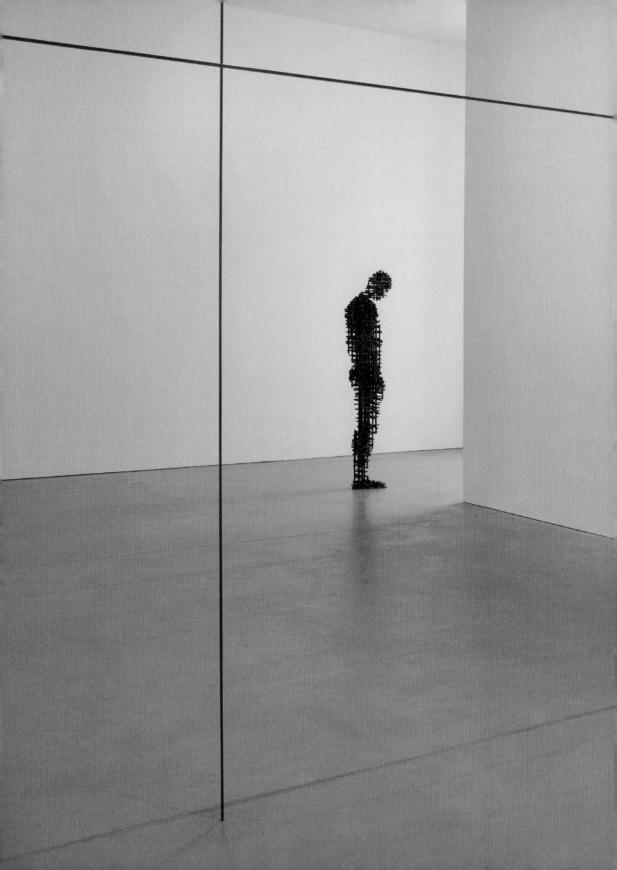

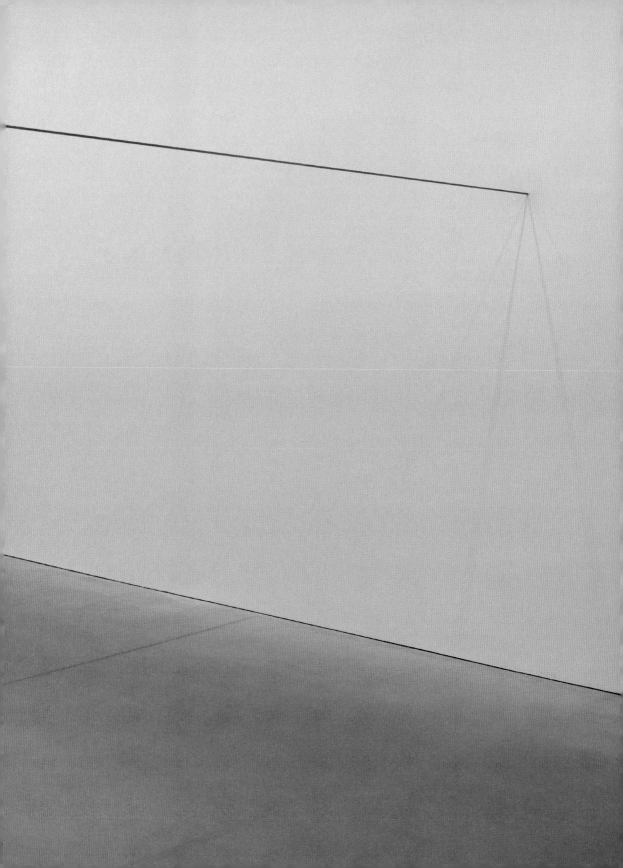

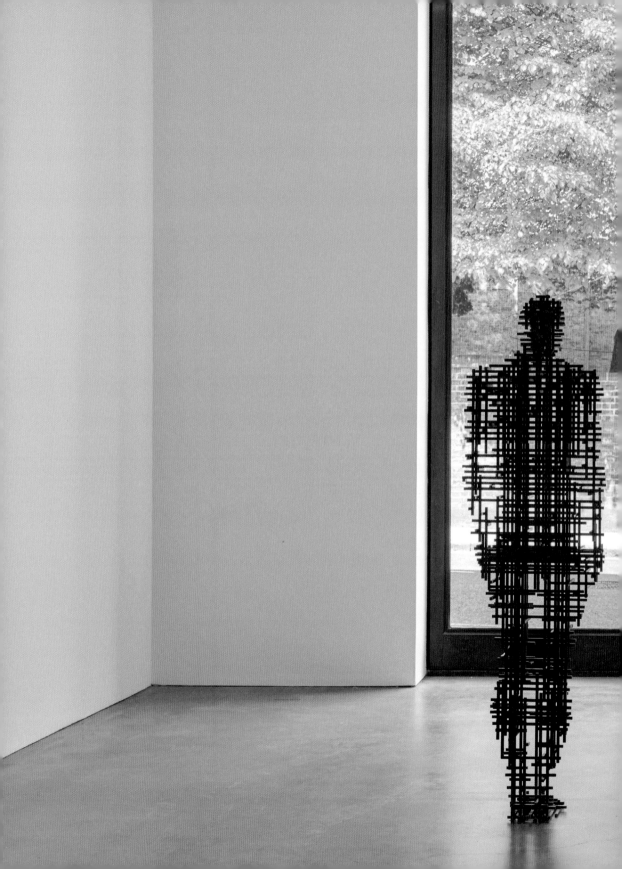

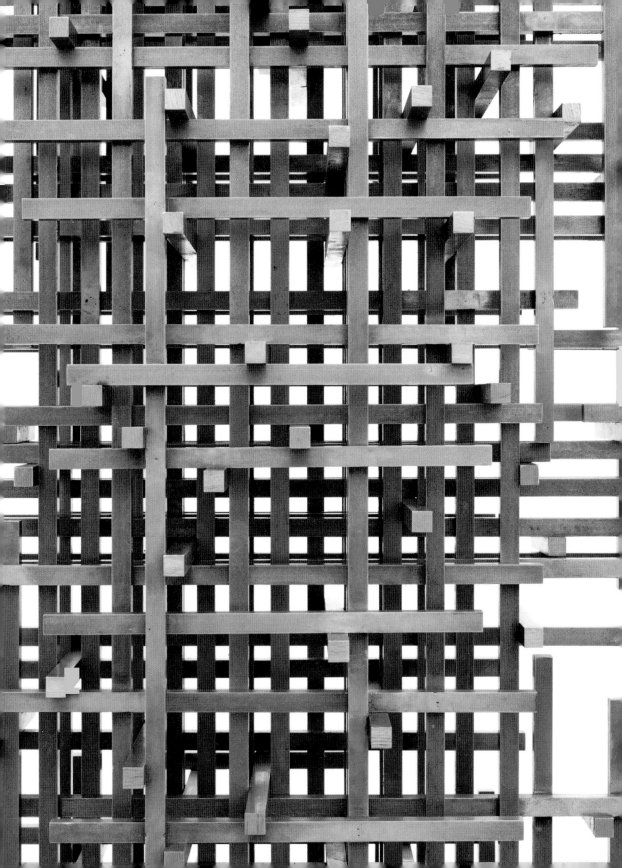

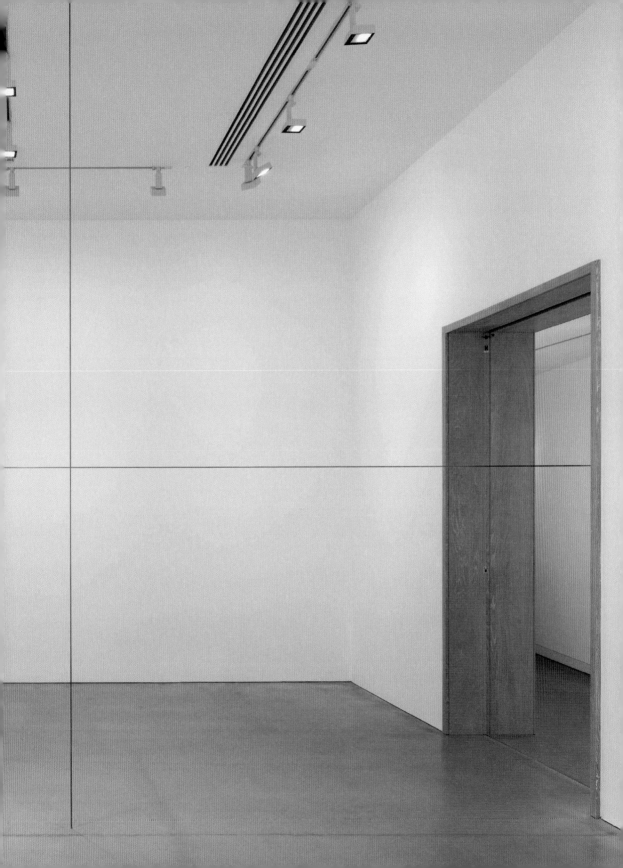

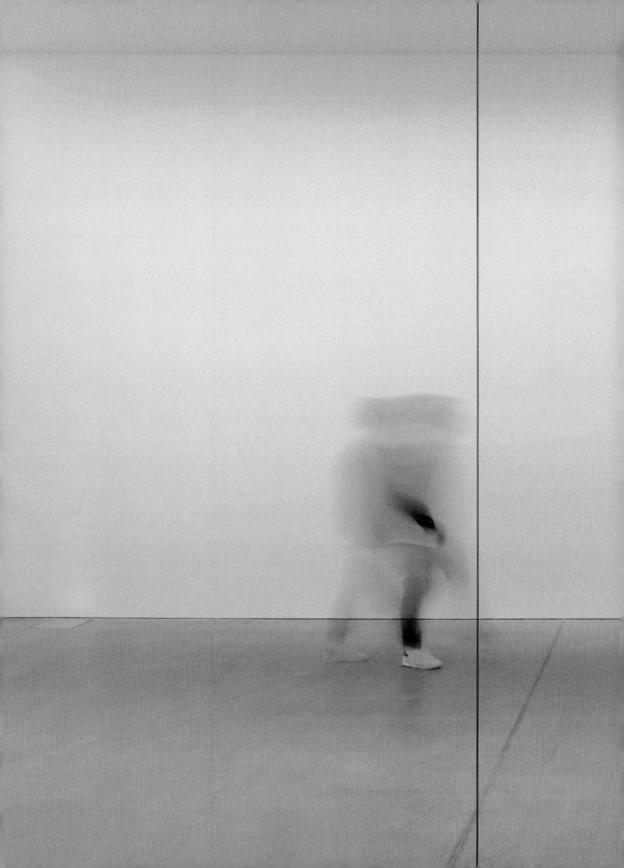

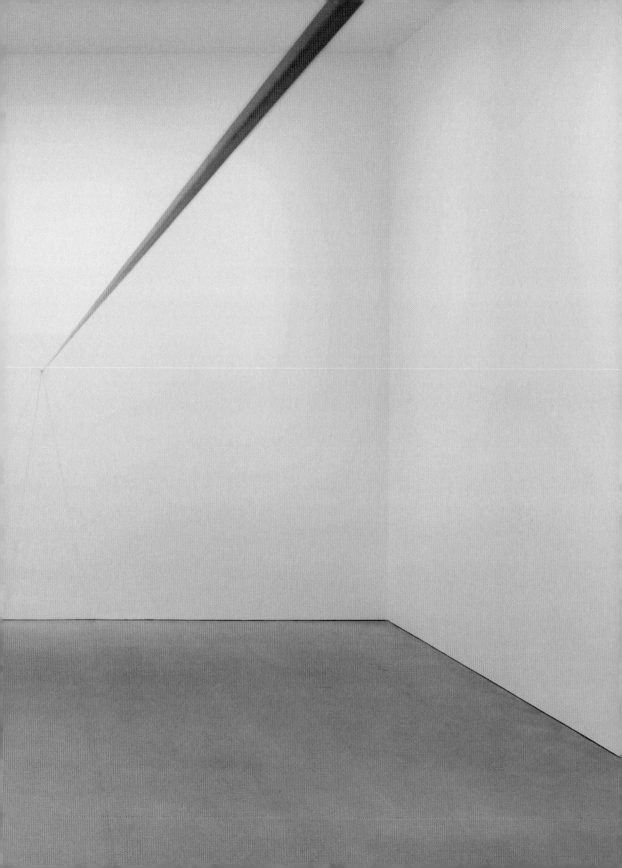

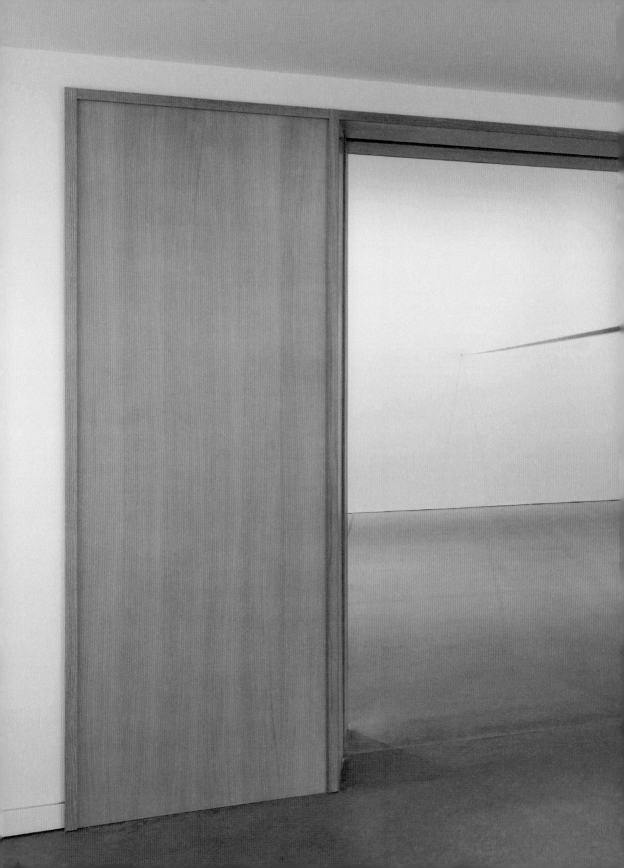

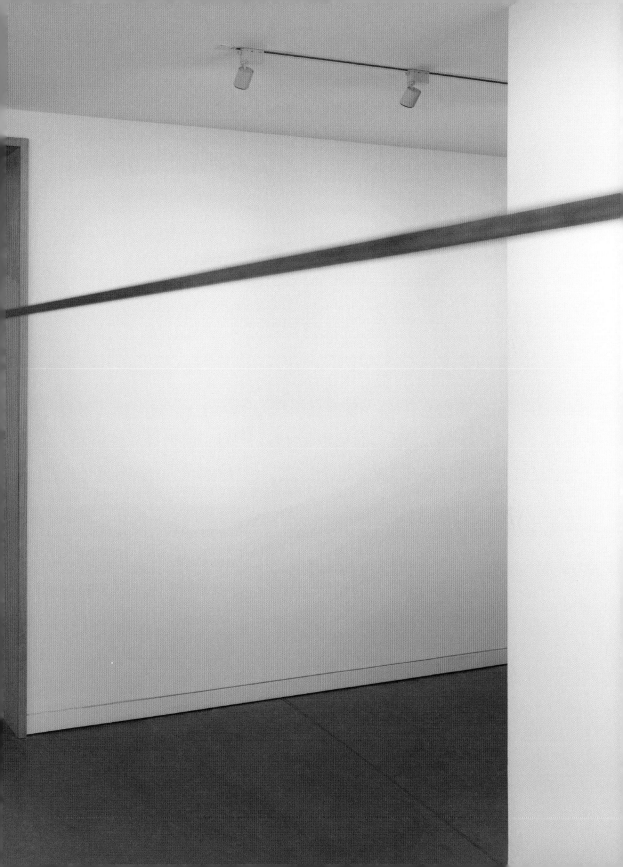

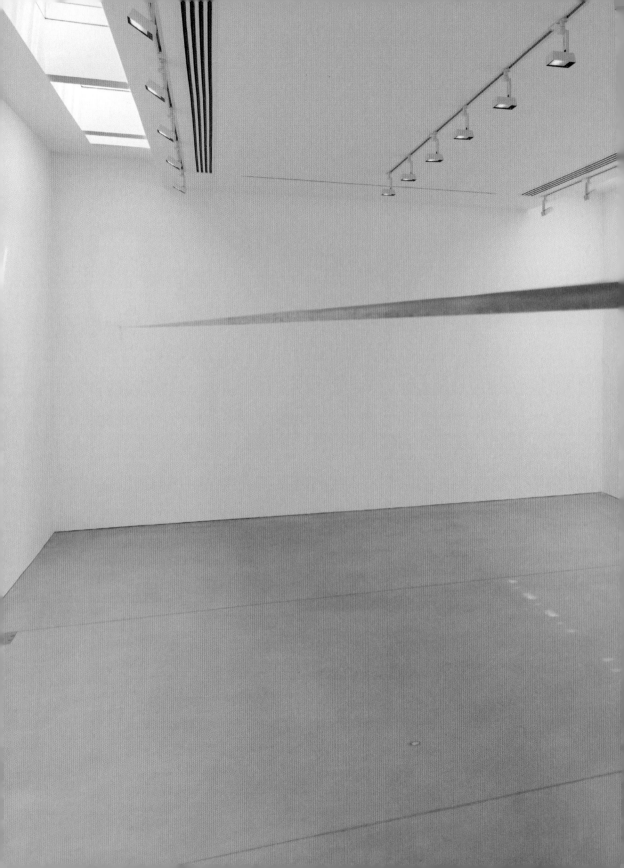

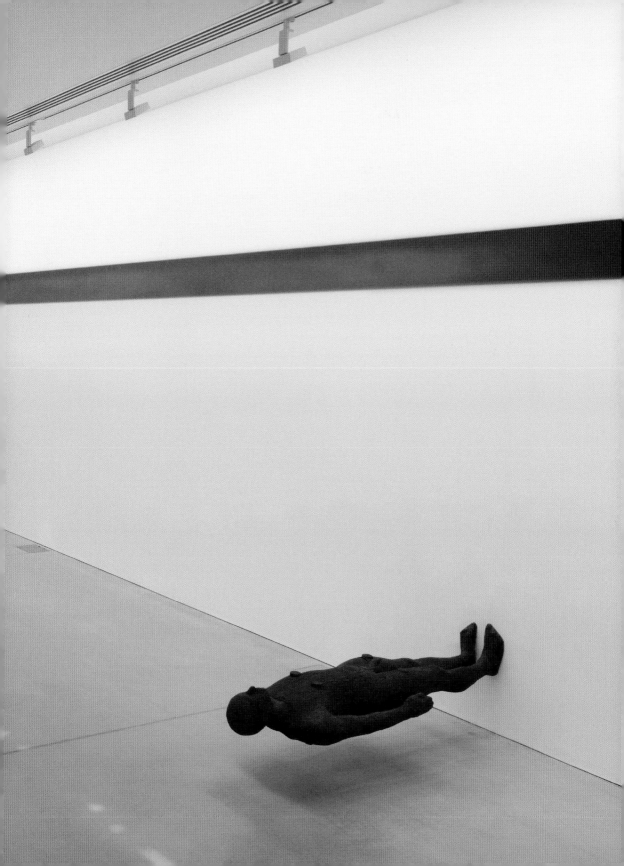

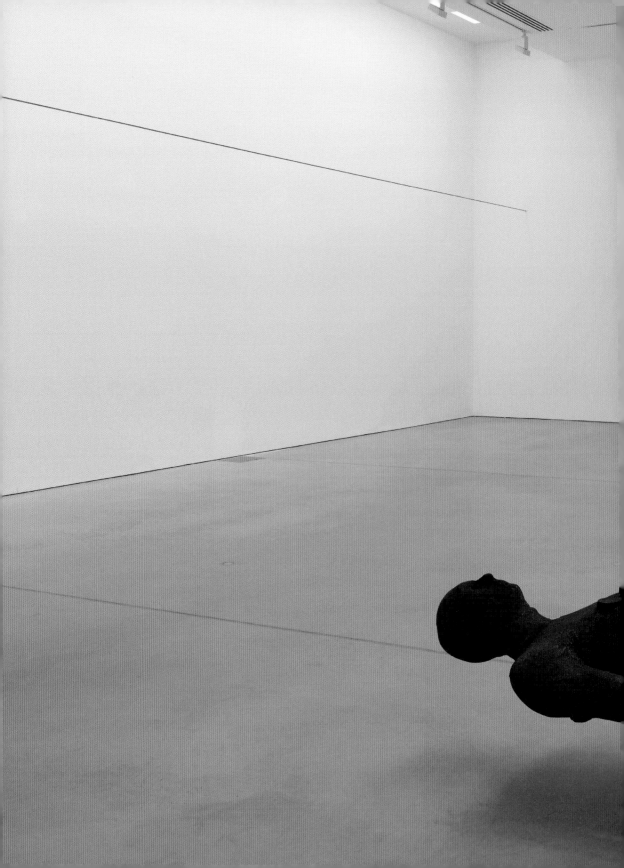

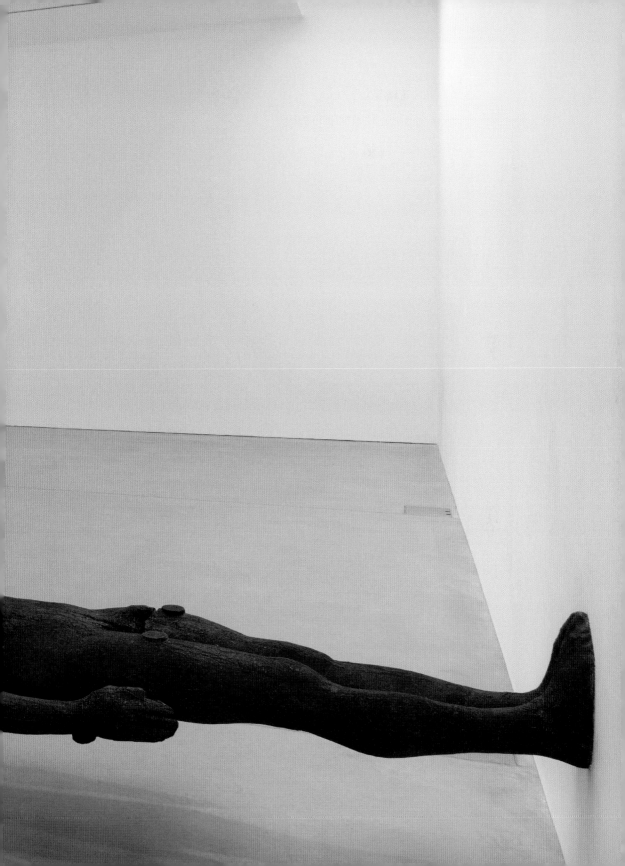

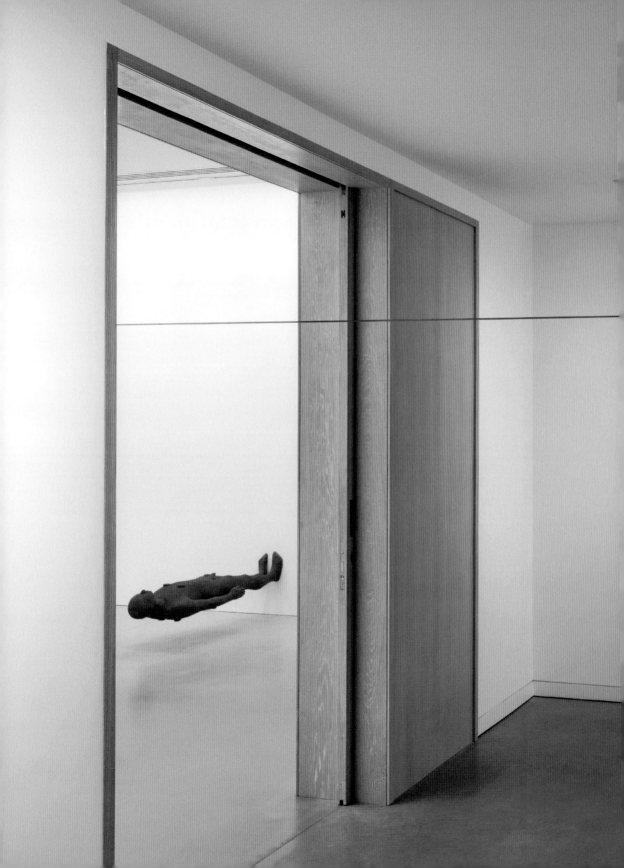

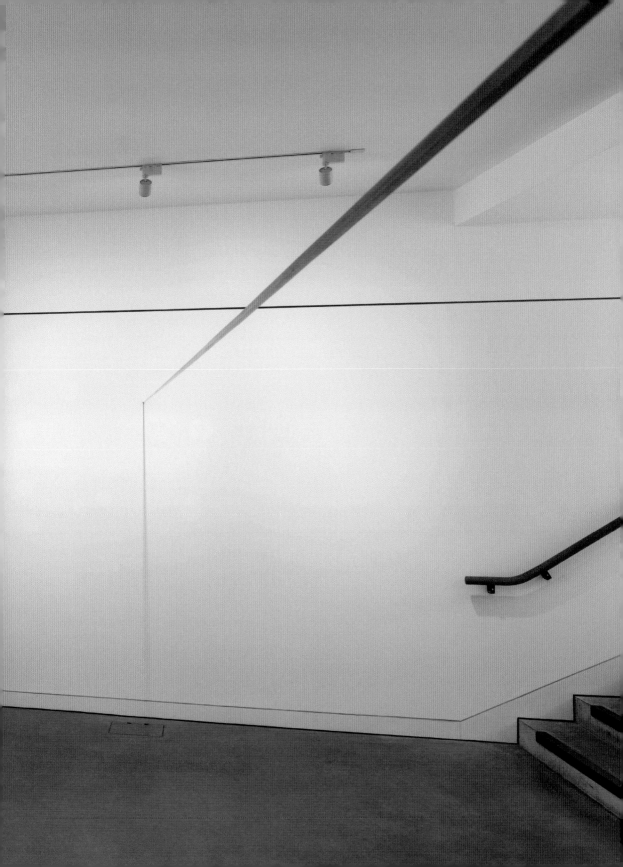

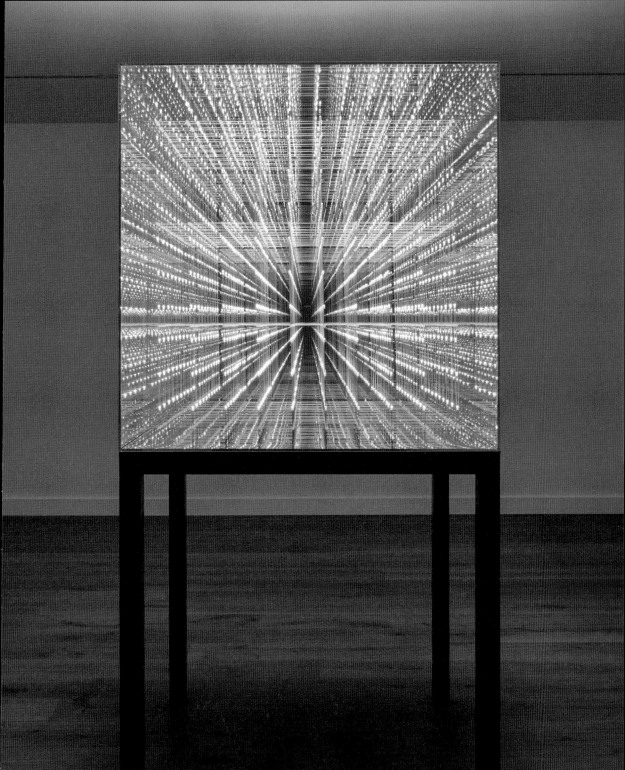

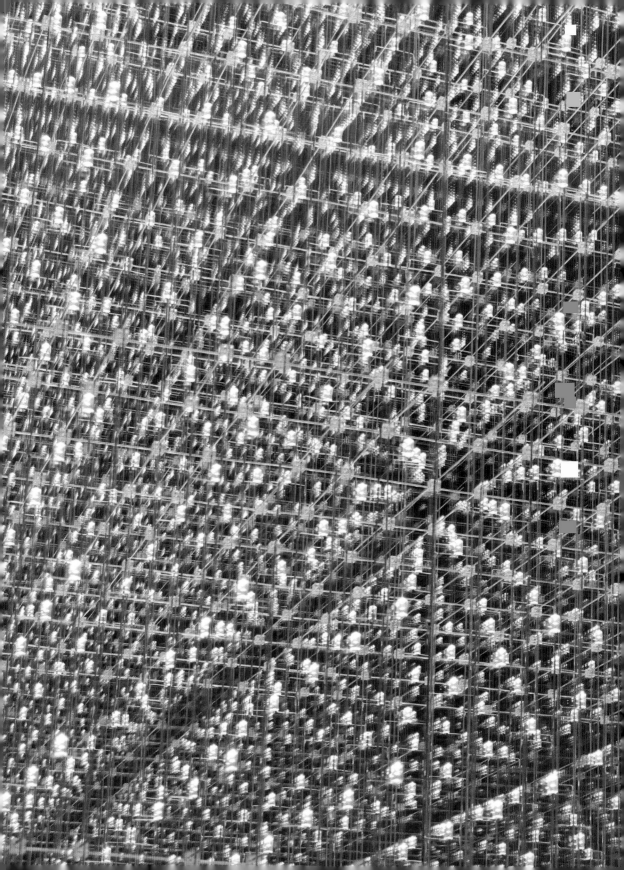

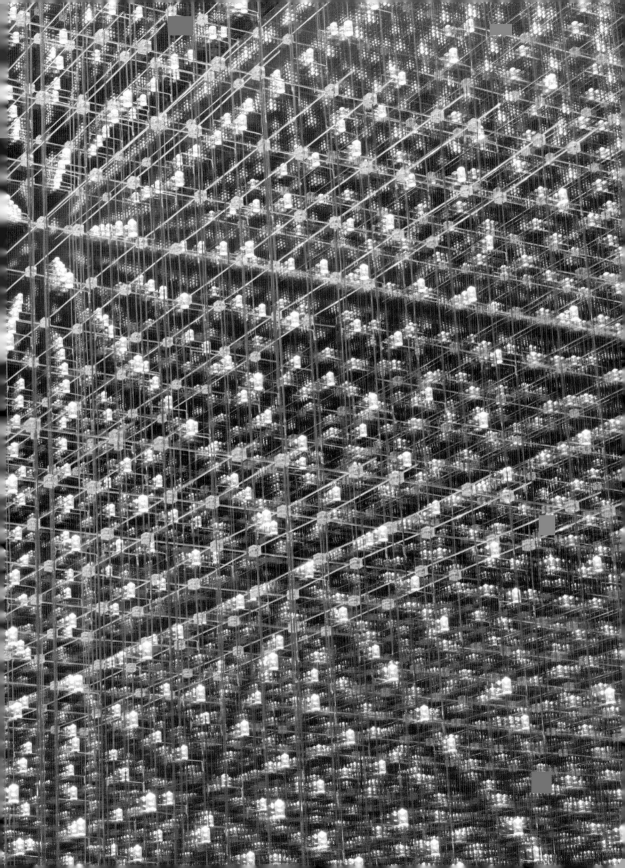

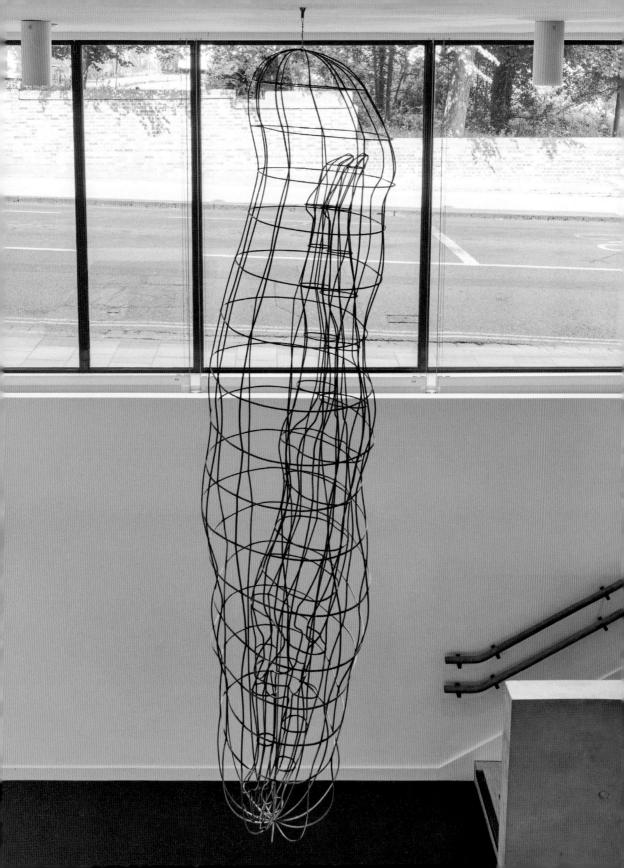

The Room Within

Caroline Collier

'... all these obsessions I have with systems, matrices, weights and measures, are only of use in so far as they put you on that precipice or edge or threshold – and in the process, I hope, make you feel more alive or more aware of your dancing self.'
—Antony Gormley[1]

'Space exists outside the door and inside the head'.
—Antony Gormley[2]

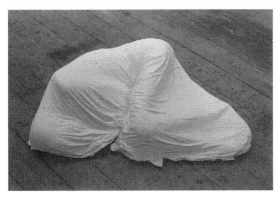

Sleeping Place, 1974
Plaster and linen, 55 x 91 x 106 cm

A person was asleep outside a shop in Oxford Street, their curled up form visible beneath a white sheet. I almost missed this isolated body on the ground. I was considering how to write about an exhibition I had yet to see and I was not fully present on that warm spring London afternoon, as shoppers flowed into the street and around the still figure, partially sealed from the crowd, but not from the traffic fumes, by a thin covering. This human body in its temporary refuge triggered a memory of a photograph of an early sculpture by Antony Gormley, whose work was the subject of the essay that was on my mind. Gormley's *Sleeping Place* was made in 1974 when he was a student at the Central School of Art and it was based on his perception of sleepers he had observed in public places while travelling in India. Drawing on his memory, Gormley asked a friend to lie down and be covered in plaster-soaked sheeting to retain the form. This sculpture was known by me

only as a black and white image but it struck me that in its evocation of the vulnerable human body as a temporary dwelling place and its suggestion of the way a body inhabits the space around it, the piece related to the exhibition for Kettle's Yard.

This exhibition, entitled SUBJECT, would investigate subjective experience through the body and architecture, consistent themes for the artist. Gormley proposed to test and to link five of architect Jamie Fobert's new spaces for Kettle's Yard through five sculptures. In conversation, Gormley defined for me the central proposition of the exhibition: 'Can we take an idea of objective measuring of space or designation of space as a means to reinforce subjective experience?' He added another 'research question' that relates to his view of the world in the twenty-first century and that is

a challenge for all public galleries and a plea to this most intimate and domestic of art museums: 'what is the role of aesthetic experience at a time of mass imbalance, a time of false desire and need?' I took this to mean that if art does not prompt thought, feeling, action in the viewer, what is its point? And if the effect of art is vital for the future, what kind of institution, as well as architectural spaces, enables art to communicate freely its hopefulness and promote empathy, imagination and co-operation in viewers or participants?

Antony Gormley was born in London in 1950, the youngest of the seven children of an Irish Roman Catholic industrialist father and a German mother who had come to London to teach physiotherapy and had learnt therapeutic eurythmy, the system

Room, 1980 (detail)
Socks, shoes, pants, trousers, shirt, pullover, vest, jacket and wood, dimensions variable

of movement developed in Switzerland for music education and espoused by the philosopher Rudolf Steiner. Gormley read anthropology and history of art at the University of Cambridge, and then, as did many young people from the West at the time, he set off for Asia, where he remained for three years. The discipline of Buddhist meditation that he learned in India had an enduring impact on his values and his habits, as well as his art.

On his return he began his formal art education, at Central, then Goldsmiths and the Slade. He started to be noticed by the art world towards the end of the 1970s and in 1981 was included, with seven other artists, amongst them Richard Deacon, Edward Allington and Anish Kapoor, in the exhibition *Objects and Sculpture* presented at the ICA in London and Arnolfini in Bristol.[3] I remember seeing this show in Bristol – it seemed important as it picked up on a new tendency in sculpture towards a sense of the lived world, and of metaphysics, beyond formal concerns. But this was not presented as a movement: the artists, and in particular Gormley, were careful to emphasise their singular practices. The curators only went as far as identifying some 'shared characteristics'. I remember I was struck by Gormley's disconcerting lead-covered sculptures that sealed off, as if from nuclear attack, 'found' natural and man-made objects, in a material also associated with alchemy. They had an effect on me – I felt claustrophobia, the objects seemed buried, trapped in their poisonous protective skins. In the same year Gormley had a three-week exhibition at the Whitechapel Gallery, London, following Tony Cragg in a series that highlighted new art. At the Whitechapel one of the works Gormley showed was *Room* (1980), a space with walls made from his shredded clothes – another early indication of his enduring interest in ritual, architectural space, the body, skin and thresholds. Soon afterwards,

he began to experiment with casting his own body in plaster as 'found object' or Duchampian 'readymade', working at first with his wife, the painter Vicken Parsons, the body positions seeming to owe something to the eurythmy practised by his mother.

The questions Gormley has addressed through his art, in sculptures, drawings and large-scale installations in and well beyond galleries across the world are existential and to a certain extent anthropological, as he has pointed out. Human fallibility and responsibility, connections between small and large human actions and the ecosystem, consumerism and spiritual alienation, how to communicate what it is to be present in a lived moment, and why this breathed experience is significant, seem to me to be topics addressed by Gormley in various ways over the forty years of experimental practice that have made him one of the most popular, acclaimed and serious artists of his generation. His art speaks of and to the fears and hopes of people in the late twentieth and early twenty-first century in remarkable and prescient ways.

In dealing with existential questions, he has used his own body and experience as a core principle, reference point and material. He has drawn on ancient history and earlier Western and Eastern sculptural traditions as well as twentieth century art. Most influential – certainly on his large-scale works in the landscape and his insistence that sculpture should act on the experience of the viewer (never carrying narrative, despite the 'figuration' of much of Gormley's sculpture, but conveying emotion and meaning) – are American artists such as Carl Andre, Donald Judd, Walter De Maria, Robert Morris, Bruce Nauman, Richard Serra, Robert Smithson and others, all active in the 1960s and experienced by Gormley in the 1970s. In the book *Antony Gormley on Sculpture*, based on a series of BBC Radio 3 lectures he delivered in 2009, Gormley highlighted single works by artists including Jacob

Epstein, Constantin Brancusi, Alberto Giacometti, Serra and, significantly the German artist and activist Joseph Beuys, whose project, to unite the catalytic power of art with individual human experience and the human spirit, while dealing with cultural and social questions, struck a strong chord.[4]

Gormley's interests are wide ranging and pick up on the preoccupations, intellectual debates and ideas of the increasingly global era through which he is living – the Cold War and fear of the atom bomb, environmental disaster, climate change, chaos theory, new physics and quantum theory, displacement of peoples and the uprooting of communities, fast social and technological change, the psychic and spiritual condition of human beings living in cities as if sealed in rectangular boxes and geometric forms, yet mortal and affecting the organic and planetary system – all these fields of enquiry have moved and stimulated him. In terms of his processes, he has experimented with multiple materials and ways of making – from the hand made to industrial engineering and digital imaging – all used as methods or tools. And he has worked alone and increasingly collaboratively, either with assistants in the studio, with communities or with scientists and thinkers, as well as choreographers.

Gormley has said that he wants his art to start 'where language ends', making 'reflexive objects' that prompt new experiences in the viewer. Drawing is integral to Gormley's practice, ideas flowing into the sculptures through small work-book notes and sketches (finished drawings are also represented in some of Gormley's exhibitions as a parallel activity). His drive to convey what it is like to be alive and to investigate the role of art in the world has been achieved through a focused and prolonged process of action, making, testing,

discovering, reflecting, feeling and thinking, through conversation and collaboration, never by rote.

Recently I was given a small book of essays by scholar and novelist Daisy Hildyard. While reading it an image of the horizontal cast iron sculpture *Edge III* (2012), one of the five works chosen for this exhibition, came into my mind:

'Climate change creates a new language, in which you have to be all over the place; you are always all over the place. It makes every animal body implicated in the whole world. Even the patient who is anaesthetized on an operating table, barely breathing, is illuminated by surgeon's lamps which are powered by electricity trailed from a plant which is pumping out of its chimneys a white smoke that spreads itself across the sky. This is every living thing on earth.'[5]

The sculptures in this spare exhibition at Kettle's Yard have been chosen to get to the essence of a subject and, perhaps, to unsettle the viewer, prompting a 'recalibration', as Gormley puts it. They are experienced in relation to each other, in a concentrated manner, within a sequence of architectural spaces. The exhibition SUBJECT can be said, in the mathematical definition, to imply constraint. The five linked sculptural elements operate as single works and offer different perspectives on the core idea: the relationship between the organic body to the hard edged, constructed habitat of human beings, raising the question as to whether geometry and precision, co-ordinates, maps and models deaden the imagination or can provoke the release of energy and emotion.

The first encounter is with the thin steel bars that, at high tension, define horizontal co-ordinates that link the different levels of the site, piercing the walls of the new gallery. A version of *Co-ordinate* was installed in 2017 in the remains of a fourteenth century chapel in San Gimignano. The work has been re-conceived for Kettle's Yard

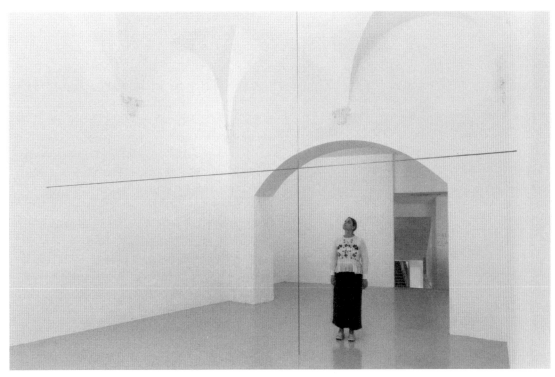

Co-ordinate III, 2017
6 mm square section mild steel bar, one horizontal and one vertical dissecting line, dimensions variable. Galleria Continua, San Gimignano, Italy

as a 'tuning device' that highlights the way the architecture has dealt with the sloping site, with Jamie Fobert responding to the constraints and the solutions to these found by Leslie Martin in his earlier extension to the house. Gormley has installed sculptures in wild places and archaeological sites where he has taken a consistent co-ordinate across body forms of identical dimensions in an uneven terrain by using plinths of different heights or submerging the sculptures to maintain a horizontal plane, horizon line, or even an eye line, that connects the figures across a landscape. At Kettle's Yard, he makes the viewer at first confused, disoriented, even – your perception of space and the relationship between things is thrown – then you become aware of the wider, less constructed

world beyond the gallery, and of the gallery itself, in a new way. Gormley uses the intersection of the two horizontals and the vertical line to re-orientate the viewer, drawing right angles in space, inevitably calling up the crucifix as well as the language of Malevich, Mondrian – and of modernism.

Beyond the crossed steel lines positioned near the entrance of the Sackler Gallery is another drawing in space that takes a human shape, its back to the viewer, head bowed, perhaps in contrition or in humility. The sculpture *Subject* (2018) was created for this exhibition. It is made of the same material and uses the same 'orthogonal' language of architecture as *Co-ordinate* to describe the form of a human body. In earlier works such as *Allotment* (1995), Gormley took measurements of people and created

Time Horizon, 2006
Cast iron, 100 bodyforms, 189 x 53 x 29 cm
Parco Archeologico di Scolacium, Catanzaro, Italy

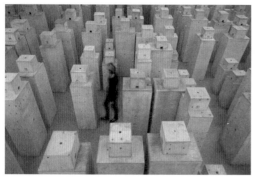

Allotment II, 1996
Reinforced concrete, 300 life-size elements derived from the
dimensions of local inhabitants of Malmö aged 1.5–80 years.
Kunsthaus Bregenz, Austria, 2009

body chambers of concrete that call up individual bodies, communities or cities. *Subject* is one of many sculptures and immersive installations made over the last ten years that use different mathematical and digital languages and techniques to evoke or provoke subjective experience in the viewer and that test how far the trace of humanity remains, despite or within the geometric model or formula used.

The sculpture *Subject* also belongs to a family of lead bodycase works derived from a scan of the same plaster mould of the artist made over two decades ago. In recent sculptures, a digital scan is often taken direct from the artist's body, allowing for more flexibility and speed and a wider range of postures; however, *Subject* is born from the arduous process of holding a position while a mould is taken. I visited Gormley's studio in London in April to see *Subject*, this new work that shares its name with the exhibition. By chance, a much earlier sculpture had returned to the studio, *Into the Light* (1986–7), one of the many lead 'bodycases' clad in a lead skin with geometric welded seams. The artist pointed out that the co-ordinates of vertical and horizontal lines of the welding are strictly and logically applied to the asymmetrical position of the earlier sculpture, the central vertical passing through the left foot – a link between this and the disciplined mapping evident in the Kettle's Yard show. But what struck me was the closed and inward nature of the earlier sculpture (and *Edge III* at Kettle's Yard) in comparison to the open grids of *Subject*. This cuboid structure invites the viewer to inhabit the artist's body and by implication his psyche as a set of rooms, a modernist mansion of many chambers, or city of many blocks. Both *Into the Light* and *Subject* are derived from body positions suggesting reverie, reflection, inner life. *Into the Light* conjures a private realm of the imagination and memory, a place of secret darkness. But strangely the new work, with the body rendered as geometry, from a computer model, seems more

intimate and porous, more welcoming and playful in its invitation to the viewer to identify with the trace of mortality imprinted in or revealed by the mathematical formula. The earlier work called for empathy – the recent work is a sort of climbing frame for the imagination of the viewer, stimulating the viewer's own experience rather than conveying predominantly the artist's. There is no skin that seals off the body of *Subject* from the world around it, just a prickly armature of steel rods. Somehow the figure feels connected to its environment and to the viewer, despite the limited structure of right angles.

The other gallery appears at first to be empty, save for the longest of the horizontal bars of *Co-ordinate*. *Edge III* is revealed as you come out of the larger gallery, or if you choose to enter Gallery 2 first you will see it: a body uncannily fixed to the wall on a horizontal plane, hovering above the floor at bed height like a redundant girder. The iron man is both vulnerable and polluting, cut off from the world and implicated in it, this male body arising from twentieth century production methods that have sickened the earth yet in their grandeur still exert an imaginative pull. Like *Subject*, *Edge III* may imply humility: here is Gormley's body form offered up to the viewer's gaze, turned by 90 degrees to become a prone and imperfect Adam, with the means of its making left visible on its skin as four cylindrical protrusions.

Gormley's exhibition extends beyond the galleries into the learning and research spaces at Kettle's Yard, reinforcing his points that prompting experience and reflection, rather than spectacle, appearance or aesthetics, is core to his belief in art and to this show. *Slip I* (2007) is a diving human form, again cast from Gormley's body, presenting itself as a husk or essence within the frame, pod, cage, womb or chrysalis that surrounds it. Like *Edge III*, it is disorientating and incongruous, but it is the most organic of the works here: its form is looser.

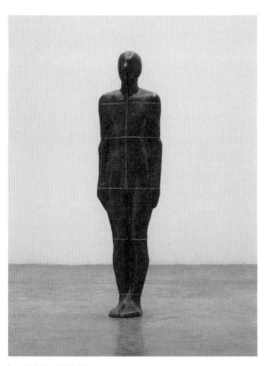

Into the Light, 1986-87
Lead, fibreglass, plaster and air, 193 x 50 x 38 cm

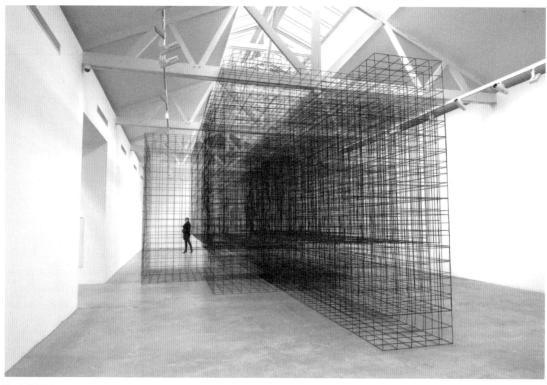

Matrix II, 2014
6 mm mild steel reinforcing mesh, 550 × 750 × 1500 cm. Galerie Thaddaeus Ropac Pantin, Paris, 2015

People will continue to use the space for making art, talking and learning, around the sculpture, a steel cobweb or falling angel that is suspended from the ceiling. Like *Subject* above in the gallery, *Slip I* too is visible from a window onto the street. If these sculptures are open to the world beyond the gallery, *Infinite Cube II* (2018), sited upstairs, offers infinity in a box. The sculpture *Into the Light* struck me as an inner chamber, a sarcophagus, and in its own way *Infinite Cube* too is a sort of tomb, where all experience, all consciousness can be held but never grasped, ad infinitum. This is an unusual work for Gormley to have made, a realisation of the obsession of and a tribute to (as well as, I think, a memorial for) a younger collaborator of the artist, who took

his own life, whose preoccupation was the matrix of infinity and whose name was Gabriel, like the angel.

The sculpture, set on a metal plinth, offers an inward realm of an endless and simultaneous set of grids, corridors of mirrors, light and logical measurement that cannot be pinned down, a psychic puzzle that changes as you move. In its concentration, it recalls Borges' *The Aleph*, a short story referred to by Gormley and influential on Gabriel Mitchell. This may be the matrix for experience and consciousness, beyond appearance, containing everything, or, more terrifyingly, an unbearable nothing: 'Each thing (the glass surface of a mirror, let us say) was infinite things, because I could clearly see it from every point of the cosmos.

I saw the populous sea, saw dawn and dusk ...'[6] *Infinite Cube* could be read as a void or as consciousness, memory or essence, beyond the body and the earth. For all its modernity of form, its aseptic structure, its meaning may recall another of Gormley's inspirations, a fragment from St Augustine's confessions from 480 AD, where the saint describes memory and by implication imagination, close relation of consciousness, as 'a spreading limitless room within me'.[7]

Focus, the desire to go further, seem to be moral principles for Gormley: 'mindfulness' and stretching himself through concentration are his 'praxis', the way he lives his life and makes his art in a state of congruence. The psychologist Mihaly Csikszentmihalyi, writing about research into 'optimal experience' for human beings, that is, autonomy in consciousness or the condition of 'flow' (experienced for instance in the creative process) points to the tendency towards analysis, measurement and differentiation in Western cultures that has, he argues, enabled human beings to build, alter and to destroy their environment and has brought about confusion, malaise and unhappiness. At the end of his book, he suggests a counter tendency, towards integration:

'The most promising faith for the future might be based on the realization that the entire universe is a system related by common laws and that it makes no sense to impose our dreams and desires on nature without taking them into account. Recognizing the limitations of human will, accepting a cooperative rather than a ruling role in the universe, we should feel the relief of the exile who is finally returning home. The problem of meaning will then be resolved as the individual's purpose merges with the universal flow.'[8]

Antony Gormley's 'subject', the essence of his practice as an artist, seems to me to reveal this kind of optimism – a hope that is in its way as utopian as that of any modernist – but is implicated in being human, limited and mortal, connected to the world outside the body through the discipline and infinite space of inner life.

1 Antony Gormley, in Martin Caiger-Smith *Antony Gormley*, New York, Rizzoli, 2017, p.419.
2 Antony Gormley, in *Antony Gormley: Five Works*, London: Serpentine Gallery, 1987, p.13.
3 *Objects and Sculpture*, exhibition shown in two parts, at Arnolfini, Bristol and Institute of Contemporary Arts, London, May–August 1981.
4 *Antony Gormley on Sculpture*, London: Thames & Hudson, 2015.
5 Daisy Hildyard, *The Second Body*, London: Fitzcarraldo Editions, 2017. p.13.
6 Jorge Luis Borges, *The Aleph and Other Stories,* Andrew Hurley (trans.), London: Penguin Books, 2004, p.130.
7 Quote from St Augustine, *Confessions*, chapter XVI, in *Antony Gormley*, (2nd ed.), London: Phaidon Press, 2000, p.111.
8 Mihaly Csikszentmihalyi, *Flow*, (2nd ed.), London: Rider/Random House, 2002, p.240.

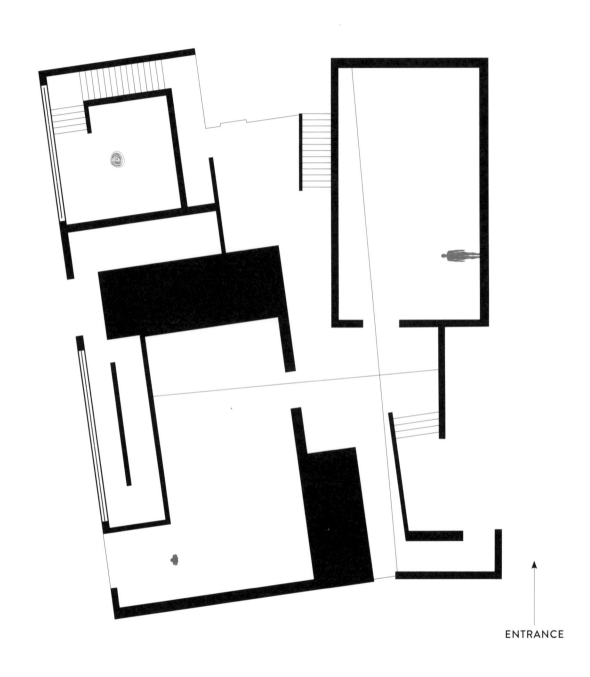

ENTRANCE

SUBJECT, exhibition floor plan for Kettle's Yard

In Conversation

Jamie Fobert, Antony Gormley and Jennifer Powell

JENNIFER POWELL: What is your recollection of the first time you met?

ANTONY GORMLEY: I met Jamie when he was working with David Chipperfield and he helped with our house. We made this studio here at King's Cross because the house is close-by: one thing leads to another.

JAMIE FOBERT: It was early in my time at David's. I had recently arrived in London from Canada and to work with David was an amazing opportunity. I learned a tremendous amount from him.

AG: Jamie is a man who understands making. He understands architecture from the point of view of the inhabited. It was natural that when we needed the house extended, we worked together. He opened the ground floor up so we now live with our garden the entire time. His design allowed the floor level to continue into the stone paving outside. Jamie inherited from David Chipperfield an understanding about light, body, space and material.

JF: I have a wonderful memory of coming to the house [in 1993 or 94] and Antony and Vicken [Parsons] bringing the kids, who were very young at the time, to the table. We were discussing whether the window frames overlooking the terrace should

be white or black, and Antony was horrified that I thought these were the only two options. We looked at a colour chart and Antony's son, Guy, picked out a very dark purplish brown.

AG: It is really very easy to think, having grown up with Modernism, that clarity of articulation should go from wall to window: a white wall should have windows with mullions painted white, but it doesn't work. When you're looking out from a house, you want the glazing mullions to disappear.

JF: Windows have a dual purpose; first allowing in a quantity of light, and second, of framing. In my five years in architecture school, no-one had described the function of a window in the same way as the photographer Nick Knight, who was my first client at David's. Equally, working with Antony, the level of conversation was fantastic. He had a completely holistic understanding of the relationship between nature and view. It is good to see architecture through the eyes of an artist.

AG: Jamie has a sensitivity to scale and how material translations of a design can be carried out. Drawing and model making, but also conversation with the people you are working with, are important.

JF: As an architect, you begin by making, of course,

through sketching and model making. Drawing is the architect's most important tool. Drawing is thinking.

JP: There are two important subjects there; one is about material, the other is drawing. You are both so careful in the way in which you select and work with materials. You mentioned developing an architectural attitude to language, Antony. All of the people who you work with in your studio seem to really understand that language.

AG: The evolution of sculptural language started from the hands-on attempts at replacing the relationship between bone, muscle and skin with something else closer to construction. In the old days, your passport to being a sculptor was the understanding of anatomy, but I returned to the body, trying to find something else. If we can think of the body less as a protagonist in narrative, less as about making a statue and therefore about idealization, portraiture, or memorial, can we think about the body more as a place? If we jettison the body in motion, then we are into architecture.

JP: The body as architecture?

AG: Yes! How can I begin to describe the indoors of the body; the body at rest – still. You start thinking about how your two legs are pillars and your pelvis

is a lintel. From that point onwards you are building the torso as a column. If you are not interested in appearance and portraiture, the perfect copy of what we look like, then you start getting interested in how that load path can begin to articulate a set or an attitude in the body. That is where drawing comes in. I might draw to work out how to make something, but much more important is the drawing that takes me into that gestalt, the exploration of the feeling of being, of inhabiting a still body-space. What does it *feel* like to look out from this space?

JP: This is how your sculptural language develops.

AG: It comes out of an investigation of the body as a place of indwelling ... that's what is driving the work.

JP: Let's talk about your exhibition at Kettle's Yard, which is the first by a single artist to inhabit and activate Jamie's new spaces.

AG: The show that I have made is in response to Jamie's architecture and his experiment with space. Jamie has been asked to carve out space in an already existing footprint with spaces that were difficult to reconcile. I want to activate these newly created spaces. I want the indwelling in relation to the body to be transferred to the spaces themselves.

tween a person and an object, a person and a book, or a person and another person' —AG

JP: The works you have selected for Kettle's Yard are drawn from different periods of your career, some are completely new and some have never been shown in the UK. What was the thinking behind those decisions?

AG: Well, I thought, let's test this new gallery. At the time I was making a forty-eight-tonne granite work for an exhibition in Germany. Cambridge is an intellectual zone and I wanted to give the city a bit of weight and substance; some matter to stick in the mind. But that gave way to this response to the nature of the spaces and the idea of activating them in a less weighty way.

JP: So, then you arrived at Co-ordinate.

AG: Yes, Co-ordinate III (2017) had been shown in Galleria Continua, a fourteenth-century space with a vaulted ceiling in San Gimignano, as a vertical and horizontal line. For Kettle's Yard, I realized that we could add a second horizontal and echo the principle metrics for spatial description, and the principle metrics for all architecture and certainly for Modernism. We could do it in such a way that the lines of square section steel bar would be orthogonal to each other but separated, and as we walk through the galleries, they could unite or connect different spaces. That was a breakthrough.

The ambition of this show is to create these very slight, but literally very high-tension interventions that act like tuning strings for the spaces involved.

The three lines of steel bar will be under three or four tonnes of pressure. It will be interesting to see how people react to these lines, but the idea is that the subject transfers from the object on display to the viewer and their relationship to the space as a whole. Co-ordinate acts as a catalyst for proprioception.

This decision about how to animate the spaces evolved into a 'weave work' that uses the same x, y, z co-ordinates to describe a human space in space – something that is both open and dense, rationally constructed but emotionally potent.

The third part of the show is a raw body cast, Edge III (2012) placed into the space as a lever: a 630-kilo cast iron bodyform stands on the wall, at the height of a bed – another instrument to encourage the viewers to become participants.

JP: Yes, and I am really excited by the way that Co-ordinate unites the new spaces, but it also asks visitors to look beyond the walls and think about the site as one. Jamie, you have talked about how important the Kettle's Yard House is to you, how you built on the horizontal flow of the spaces.

JF: Leslie Martin was a master of shifting volumes

and spaces. As you navigate the 1970 extension he designed you constantly move forward and shift, always with a short lateral movement from one long view into another. Even though there is a double height volume, I always felt that the architecture was predominantly horizontal. Some of the built elements that had been added since the 1970s broke that pattern, so those added spaces felt disjointed from the rest of Kettle's Yard. It was important to us that the meandering sensibility of the house and extension was maintained. It seems so informal, but it was in fact very well-conceived informality.

AG: The main characteristic of the site is the levels and the way the levels are dealt with. This is something that *Co-ordinate* also picks up on. In the cottages, the integration of stair into room is quite unusual, this flows into the Leslie Martin building, but in a different way. The whole of Kettle's Yard has this sense of waiting for conversation, waiting for exchange either between a person and an object, a person and a book, or a person and another person. Jamie has respected that, but also opened it out.

The characteristic of the Leslie Martin core is an entirely internal world. By opening up the Castle Street façade, allowing visual access to the main gallery and down into the education space, Jamie has changed the face of Kettles Yard.

The two shops that stood where the education spaces now are, were the antithesis of the four cottages. Yet Jamie, in his wish not to impose, has displayed their inherent neutrality, but made that extremely positive, because the spaces, with these new windows, now have an openness to the street, to the wider world: a quality that Kettle's Yard lacked. The early nineteenth-century cottages were shelters for yeoman labourers, for bodies otherwise exposed to the elements, which was in turn the ledge on which the sensibilities of Jim Ede could rest and multiply.

We all love Kettle's Yard of course, it is a nest in which sensibility is grown, both for its original founder and for countless others – however, what Cambridge lacked, and what Kettle's Yard sometimes reinforced, was the toughness of Modernism. The positive thing about Jim Ede's legacy is that art can be lived with, but in the domesticating of Modernity some of the really exciting parts of its vigour were castrated or transformed into aesthetic sensibility.

The important thing that Jamie has given to the gallery is the ability of a very needed ruder and tougher confrontation with art. It is interesting that Jamie's work has also engaged with the legacy of Bloomsbury and St Ives. I'm unconvinced by a pastoral Modernism, which is what happened when the spirit of Mondrian and Naum Gabo – who were both determined Futurists – became seeded in Henry Moore, Barbara Hepworth and the School of St Ives.

I'm saying that making a space for art isn't about sensibility, it's about something else, it can extend the possibilities of art: what art can be. It's not about making beautiful spaces, but making a test site for human art and life. How can art help in the making of a collective future? That is what I get from Jamie's addition – it takes us on. I hope that Ede would recognize that this is a necessary step.

JF: I think I understood, having spent so many years at Kettle's Yard and reading as many documents as I could, that Ede had a very specific project. To try and bring contemporary art back into the domestic space, and to bridge the schism that was happening in the twentieth century, between contemporary art and traditional housing. There was a sense, at that time, that if you had, say, a Rothko, that you needed a Mies van der Rohe house, that you couldn't put a Rothko in your cottage, or in anything except a Modernist house. As such, Modernism was conceived as hermetically sealed off from the past.

Ede wanted to reintegrate contemporary art into this very domestic setting, and he continued that sense of the domestic with his vision for Leslie Martin's extension. While it was being built, Kettle's Yard received a grant which prompted Ede to decide to build galleries for changing exhibitions. This contrasted with the very fixed display of how one could live with art, with natural objects, in the cottages. Those first three galleries were white-wall, top-lit, with brick floors, very much a distinct experience from the cottages. All the subsequent galleries that were added over time, were never meant to be part of the same project as the house extension.

In a wonderful interview from November 1988, just two years before Ede died, artist John Goto asked: 'With more resources you would have bought more European art?' Jim replied: 'yes, every year, and built a great gallery'. I think he recognized that they were struggling to show contemporary art practices, almost as a necessary counterpoint to the experiences in the house.

AG: I'm glad to hear that. I think what you're saying is that he recognized that there were two projects. The one was to do with arguing that art is for everyone and how much money you may have, or the kind of house you might live in are irrelevant. The compliment to that realization, is that there has to be public space, open space, available space. That is what Jamie has given, especially with the integration of the education space.

JF: Ede was also thinking about lived experience. How this space, in which objects were meticulously arranged, could also make you think and feel about the way in which you live. When he wrote about Kettle's Yard, he rarely wrote at length about individual artists' works, he was really talking about another type of experience that wasn't necessarily only linked to the aesthetic. I think that he wanted to offer a sanctuary from modern life and this was very much a reaction to his involvement in the First World War. Antony, you have often inferred that 'form' or the 'aesthetic' of sculpture isn't as important as the viewer's experience of how it makes them feel, or how they experience the space, which you get in these new architectural spaces too. Ede was interested in how his spaces could make visitors feel. It was, perhaps, also for him as much about creating social spaces, as it was an aesthetic experience.

JF: Ede wrote about Leslie Martin's work, that it developed in 'easy and individual stages'. I read this, a decade ago, and it completely struck me. For me, this image was important to carry forward

in our work. The idea of it developing in easy and individual stages, is so evident as you move from the cottages and into the 1970 extension. There is no line, no boundary and most visitors are totally unaware that they have moved from early nineteenth-century cottages, to 1970s Modernism. This is partly because there is enough continuum in the materiality; timber plank floors and rough plaster. This continuum is the thing that carries people, it is so powerful and so elegantly handled. We were keen to create the same continuity between Leslie Martin's work and our own.

When designing exhibition and art spaces, the architect has an ambiguous role compared to other types of design work because you have to anticipate, as much as you can, whatever artwork might arrive in that space, as well as anticipate the experience of the viewer. In fact, you are creating a context in which those two things, the art and the viewer, interact. Your work evaporates, or disappears, to a certain extent. But if you make it all white, then it becomes too much of a pure void and it no longer works. It is important that the space maintains some material presence, but at the same time the architecture can never come to the foreground. It is an architecture of background.

AG: It is a delicate thing. Good architecture, generally, grounds experience, allowing articulated volumes of an architectural space, to be respected and not made rhetorical. This takes intelligence and sensitivity, but also pragmatism.

JF: One thing I learnt working with David Chipperfield and with artists is that architecture is always experienced in relation to our own body. It is something the architect Álvaro Siza wrote about very movingly when he saw an ancient Egyptian chair and bed. He realized that no amount of human innovation will change the height of

a chair, and the size of a bed, that the need for a chair or a bed and its relation to the body is unchanged. So it is with buildings.

It all comes back to the human body; and you, Antony, have always been interested in the body.

That ability to measure a space against our own body: with some buildings, we have no sense, no ability to do that. But a sequence of volumes that define height and depth and change in direction can be a very bodily experience. The ability to understand space in this way, I think is really important.

When I was teaching at the Architectural Association in 2000, we gave our students a project to choose any material with which to make a piece that could be worn on the body. Antony came in to critique these 'body pieces'. What we wanted to say was that architecture is just this, but taken a little further. We envelop our bodies with structures and protect our bodies from nature. I gave the students one of most important texts, for me, about architecture by the Belgian monk Hans van der Laan, which poetically describes the house as the first thing man had to create to exist in nature.

He says [reading from the book]: 'The ground being too hard for our bare feet, we make ourselves sandals. Softer material than the ground, but tougher than our feet. Were they as hard as the ground, or as soft as our feet they would give us no advantage, but being just hard enough to stand up to wear, but just soft enough to be comfortable they bring about a harmony between our tender feet and the rough ground. Architecture is not just a matter between our feet and the ground, but the meeting of our whole being with the total natural environment. It is the thing that mediates between us and nature. In reverse, architecture is also an extension of the natural world.'

AG: I keep thinking about the bench, below the brick wall studded with holes and how everything you were saying about the inscription of the body in architecture and the way that the height of a chair hasn't changed much, is quietly stated there, at the hinge point of your contribution and Leslie Martin's.

JF: And the bench was first built by Martin and then, over time, severely altered. When we looked at David Owers's photographs of the original design, I couldn't believe how beautiful the space had been and how much had been lost. We fought hard to restore it. In fact, when the builders took the plaster off the wall, where the bench is now, they called us to say it was a disaster, and that they would have to plaster it over again, because it was full of holes. The holes were from curators drilling into the walls for hundreds of exhibitions that had taken place in that space. I walked on site and said 'Wow, that's so beautiful!' The holes are a poetic memory of the past forty years of exhibitions.

I think of architecture as a mediator, but this relationship is very different when it is between an artist's work and the viewer.

JP: Do you think sculpture could also be described as a mediator, Antony?

AG: No, I think a sculpture is a purposively awkward thing. That is the difference between it and architecture: the mother of all arts. Architecture tries to make life more livable.

JF: Art does the opposite?

AG: Exactly. Sculpture tries to make life more difficult, perhaps more interesting. Putting objects that are not necessary into the world in order to interrogate life. I don't think this is about mediation, perhaps this goes back to what I was saying about

'You can start thinking about how your two legs are pillars and your pelvis is a lintel. From that point onwards you are building' – AG

confrontation. The degree to which art can be domesticized and made an extension of our nesting instincts has to be qualified by something else, which is actually that art confronts our sense of assurance in the way things have always been. There is a deep English sensibility of making do and getting by. I'm interested in disrupting that.

Art in the twentieth century fought for an independent identity, that it didn't have to serve power, that it didn't have to reinforce a status quo, or the patron.

You could say that there are two quite contradictory parts of my vocation. One is that I want art again to be common, I want it to be part of the shared world, but at the same time, the role it plays in that shared world has to be a questioning one, not a reinforcing one. It has to be in some sense disruptive.

JF: I think there are many architects who want their work to be disruptive, disruptive in the city, disruptive in people's lives. They seem to be asking why architecture shouldn't disrupt us and challenge us. I've never really been interested in this. I go to see those buildings that are disruptive and I can enjoy them tentatively for a short time, but they are never the buildings that move me. From the beginning what really drove my work was a desire for a quietly powerful architecture.

AG: Architecture can be a conversation between the given and the possible. Somehow the architect's job is to diagnose, and then he/she can serve the potential of a place to enhance life.

JF: And yet there are many architects who are not interested in that at all.

AG: I'm sure that's true. The expressionist architect wants to turn architecture into sculpture. On the whole, they just don't work. Although, I think the best Zaha Hadid is the cast concrete building for BMW. I've been to many of her art galleries and they fight against what they contain. They distract and confuse, they are arguments for architecture as object.

JF: There are moments when it's done beautifully. Moments when architecture takes on sculptural qualities. No-one, for example, could dispute the beauty and power of Mies van der Rohe's Barcelona Pavilion as an object, and almost as a sculptural object.

AG: Or Denys Lasdun's National Theatre. You could say it's the position of the cathedral in Medieval city planning. There are needs sometimes for architecture to talk about a collective will, or dream-space. It's rare to find the opportunity to make those kinds of spaces today. Lots of people think that galleries should be, but they very rarely are.

JF: And Kettle's Yard is definitely not the place for object-building. We didn't want our work to unravel the inner beauty of what had come before but to find a way to support Jim Ede's legacy and carry it forward into the future.

AG: We can't leave Kettle's Yard as a memorial; it can have an active role and change peoples' minds about what can be considered art, who can make it and how it can be experienced.

This conversation took place at Antony Gormley's studio in Kings Cross, London, on 2 March, 2018

Works in the Exhibition

Co-ordinate IV, 2018
6 mm square section mild steel bar
One vertical and two horizontal lines
Dimensions variable
Pages 33–37, 42–53

Subject, 2018
10 mm mild steel bar
185 × 52.3 × 40 cm
Pages 36–41

Edge III, 2012
Cast iron
191 × 52 × 27 cm
Pages 48–53

Infinite Cube II, 2018
Mirrored glass with internal copper wire matrix of
1000 hand-soldered omnidirectional LED lights
176 × 88 × 88 cm
Pages 55–57

Slip I, 2007
4 mm square section steel grid and silver solder
315 × 80 × 70 cm
Page 59

Authors' Biographies

Caroline Collier was until recently Director of Partnerships and Programmes at Tate. Before that she was Director of Arnolfini, Bristol. Her career has included positions at the Del La Warr Pavilion, Bexhill, South East Arts, Brighton Museum and Art Gallery, the South Bank Centre and the Arts Council, as well as freelance work as a curator and writer. She is now an independent consultant and a professional coach-mentor.

Jamie Fobert is a London-based architect and designer. He studied at the University of Toronto in his native Canada before moving to London in 1988. Since establishing Jamie Fobert Architects in 1996, Jamie has consistently produced innovative and inspiring architecture in projects ranging from individual houses to high quality retail and significant public buildings for the arts, including the recently opened gallery at Tate St Ives; the galleries and education spaces at Kettle's Yard, which opened earlier this year; the soon to be completed galleries and barns at Charleston Farmhouse in East Sussex and most recently, The National Portrait Gallery.

Antony Gormley was born in London in 1950. He has had a number of solo shows at venues including the Long Museum, Shanghai (2017); National Portrait Gallery, London (2016); Forte di Belvedere, Florence (2015); Zentrum Paul Klee, Bern (2014); Centro Cultural Banco do Brasil (2012); Deichtorhallen Hamburg; State Hermitage Museum, St Petersburg (2011); Kunsthaus Bregenz (2010); Hayward Gallery, London (2007); Kunsthalle zu Kiel; Malmö Konsthall (1993); and Louisiana Museum of Modern Art, Copenhagen (1989). Major public works include the *Angel of the North* (Gateshead, England), *Another Place* (Crosby Beach, England), *Exposure* (Lelystad, The Netherlands) *Chord* (MIT – Massachusetts Institute of Technology, Cambridge, MA, USA). He has also participated in major group shows such as the Venice Biennale and Documenta 8, Kassel, Germany. Gormley won the Turner Prize in 1994 and has been a member of the Royal Academy since 2003. He was made an Officer of the British Empire in 1997 and knighted in 2014.

Andrew Nairne has been Director of Kettle's Yard since 2011. He is a former Director of Dundee Contemporary Arts and Modern Art Oxford. He has worked with numerous UK and international artists. In the 1980s and 1990s, as a curator in Glasgow, he organised exhibitions with artists from Eastern Europe and supported the rise of a new generation of British artists.

Dr Jennifer Powell has been Head of Collection and Programme at Kettle's Yard since 2013 and is a Lecturer in the History of Art Department, University of Cambridge. Her research interests include British and international sculpture of the twentieth and twenty-first centuries and she has curated major exhibitions on artists such as Henry Moore, Henri Gaudier-Brzeska, Anthea Hamilton, and the current Antony Gormley exhibition.

Antony Gormley Studio

Antony Gormley Studio, London

Isabel Bohan
Philip Boot
Jamie Bowler
Ruby Brown
Ella Bucklow
Emily Constantinidi
Tamara Doncon
Giles Drayton
Ondine Gillies
Robert Hope-Johnstone
Rosalind Horne
Fred Howell
Adam Humphries
Alys Jenkins
Gethin Jones
Pierre Jusselme
Bryony McLennan
Anna McLeod
Ocean Mims
Lauren Minchington
Alice O'Reilly
Laura Peterle
Maria Ribeiro
David Roux-Fouillet
Alice Steffen

Antony Gormley Studio, Hexham

Jona Aal
Chris Bell
Mick Booth
Rory Booth
Francois Brunet
Oliver Beck
Josh Charlton
Sacha Delabre
Pauline Elliott
Carmine Fortini
Jessica Freeman
Ashley Hipkin
Emily Iremonger
Dan Jackson
Joe McDonough
Mike Pratt
Carol Robson
Craig Stewart
Stephen Tiffin

SUBJECT

Antony Gormley
22 May – 27 August 2018

An exhibition devised by Antony Gormley

Curated by Jennifer Powell
Assisted by Guy Haywood

Book edited by Andrew Nairne and Jennifer Powell in
collaboration with Rosalind Horne at Antony Gormley Studio

Published by Kettle's Yard University of Cambridge
in an edition of 2000

Design by The Bon Ton (Amy Preston and Amélie Bonhomme)
Printed by Albe De Coker

ISBN 978 1 904561 77 4
Artworks © Antony Gormley
© Kettle's Yard and the authors, 2018

Photography credits:
Benjamin Westoby: pp. 33–39, 42–59
Stephen White: p. 41
Ela Bialkowska, OKNO Studio: p. 65
Markus Tretter: p. 66
Charles Duprat: p. 68

Cover Image: *Sound*, 2018

We are grateful to the following for their generous support:

WHITE CUBE

The Antony Gormley at Kettle's Yard Supporters Circle:

Galerie Thaddaeus Ropac
Chadwyck-Healey Charitable Trust
Professor Roberto Cipolla
Carol Atack and Alex van Someren
Penny Heath
Andrew and Fiona Blake
John and Jennifer Crompton
Tim Llewellyn
New Art Centre
Porthmeor Fund
Jonathan and Nicole Scott
Toby Smeeton and Anya Waddington

Art transportation and installation supported by:

KETTLE'S YARD

Castle Street, Cambridge CB3 0AQ
United Kingdom
+44 (0)1223 748 100
kettlesyard.co.uk

Director: Andrew Nairne
Chair: Anne Lonsdale CBE

Support
Join a growing group of supporters enabling us to undertake new
research, make outstanding exhibitions, work with schools, young
people and the community, and conserve the Kettle's Yard House
and collection for future generations.

Find out how you can help and become involved:
kettlesyard.co.uk/support or call +44 (0)1223 748 100